The
Catropolitan
Opera

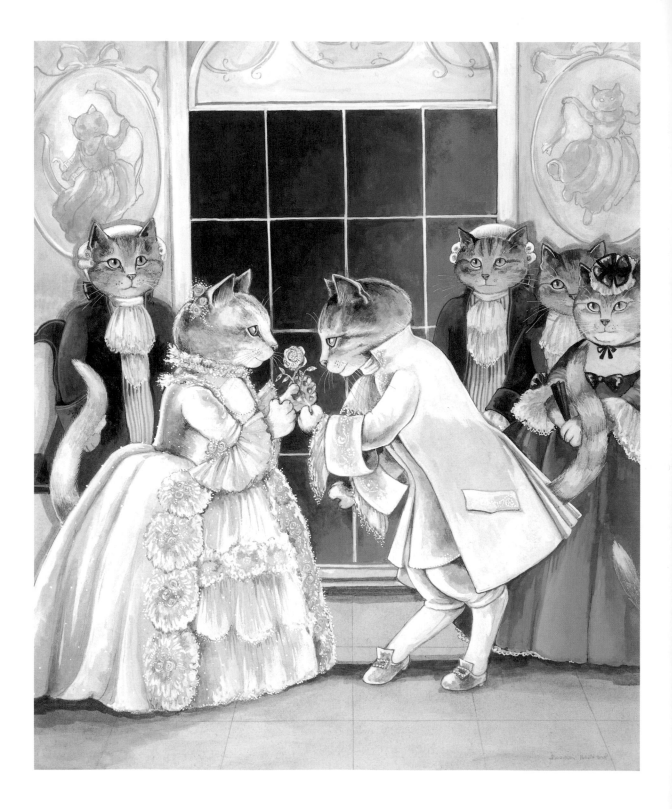

The Catropolitan Opera

THE CENTENARY CELEBRATION
OF THE GRAND CATROPOLITAN OPERA COMPANY

Susan Herbert

With an Authorized History by
Bill Meadowcane

A BULFINCH PRESS BOOK
LITTLE, BROWN AND COMPANY

BOSTON • NEW YORK • TORONTO • LONDON

FRONTISPIECE:

Der Rosenkavalier

ACT II

At the suggestion of his lover, the Marschallin, Count Octavian presents the silver rose to the young Sophie on behalf of the aging roué, Baron Ochs.

THIS 1907 PRODUCTION was one of the first to display the company's commitment to its revolutionary "New World style," in the interests of the natural cat. At last the notorious *coda cintura*, the painful restraint that strapped the singer's tail beneath the costume, could be abandoned.

OPPOSITE:

Turandot

ACT III

All the potential suitors of the cruel Princess Turandot have been executed for failing to answer her impossible riddles. Prince Calef succeeded in answering them, but, because he loved the Princess, he gave her a chance to escape him if she could guess his name.

TURANDOT WAS THE first production under the aegis of Rex Manxman, perhaps the greatest of the company's managers. Hired originally as a stage designer, his first achievement was to station scratching posts backstage, thus saving incalculable wear and tear on the scenery.

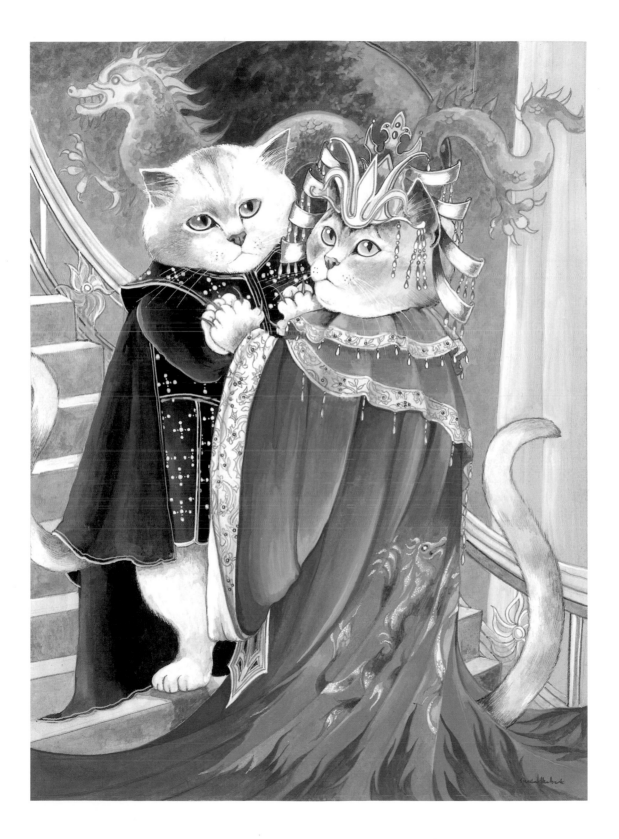

Introduction

Now that the Grand Catropolitan Opera is an indelible part of the cultural firmament — its sleek productions underwritten by Hartz Mountain and The Endowment for Cat Culture — it is instructive to cast our minds back to the company's humble, not to say scruffy, beginnings. As one might expect, it was the cats who inhabited socially ambitious households who first resolved to organize an opera company. According to company legend, after Mrs. August Belmont's cat, Schonburg, and Mrs. Cornelius Vanderbilt II's cat, Secondo, accompanied their mistresses on an Italian vacation, they returned to New York full of rapturous accounts of their evenings at the great Italian cat opera company La Scala Baffuto. Why, they wondered, was there no equivalent in America? It was but a year later that the Grand Catropolitan's first performance took place on a decrepit Punch and Judy stage in Union Square before an eager audience that ranged from alley cats to plutocrats.

From Union Square to the company's glamorous new auditorium in the Purina Center for the Feline Arts in just 100 years! It's enough to take my breath away! This book celebrates a century of the company's greatest performances and those astonishing, cataclysmic productions that have earned the company its reputation for the most uncompromisingly grand standard to be found anywhere in cat opera.

THE FIRST TRULY grand production of the Catropolitan Opera Company was Furrelli's *Aida* of 1910. Furrelli, whose European reputation as a brilliant but volatile designer and director preceded him, was hired over the objections of several board members, but his production put the company on the cat map. He arrived with a noisy retinue of secretaries, assistants, and catamites and proceeded to throw the entire company into chaos, but when the curtain rose the effect on the audience was magical.

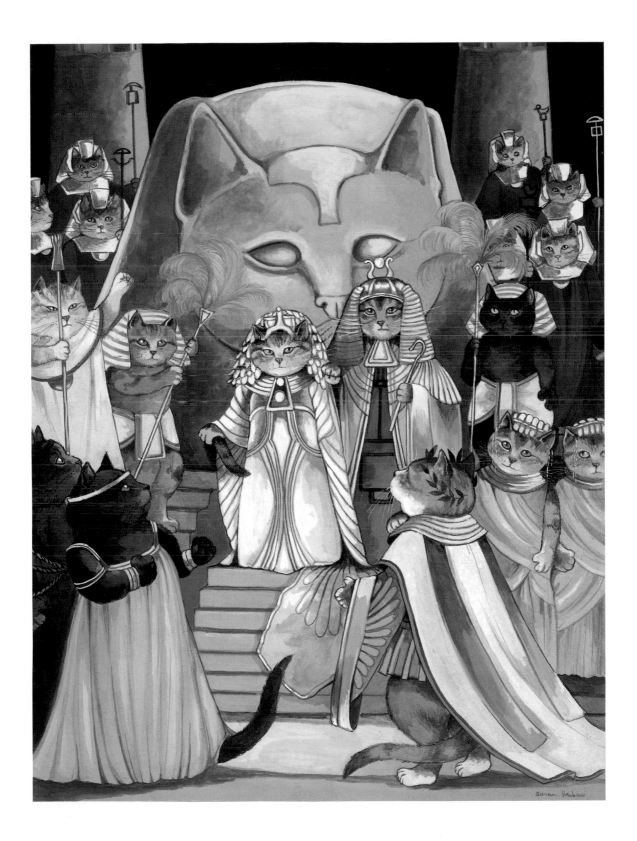

Susan Herbert

The Magic Flute
ACT I

Prince Tamino, fleeing from a savage dragon, collapses unconscious. Meanwhile, the three ladies, attendants of the Queen of the Night, vanquish the dragon and cast admiring eyes over the Prince.

THE PREMIERE of this Furrelli production was something of a disaster. The costumes and props were not ready until moments before the curtain went up and Tamino (played by the Italian tenor Tommaso Gatto) did not anticipate that when he mimed playing a tune on his flute, it would tickle his whiskers and cause him to sneeze. The sneeze produced a strange squawk from his flute. The audience giggled quietly. Moments later, when Papageno produced his bird whistle and attempted to reply, he too sneezed and produced an equally unfortunate bleat. The audience roared. During the rest of the performance, the audience broke into laughter every time the flute appeared. Finally, in Act II, when Papageno produces his glockenspiel to summon Papagena, a member of the audience shouted out "Pa, pa, pa, choo!" The opera was not performed for another decade.

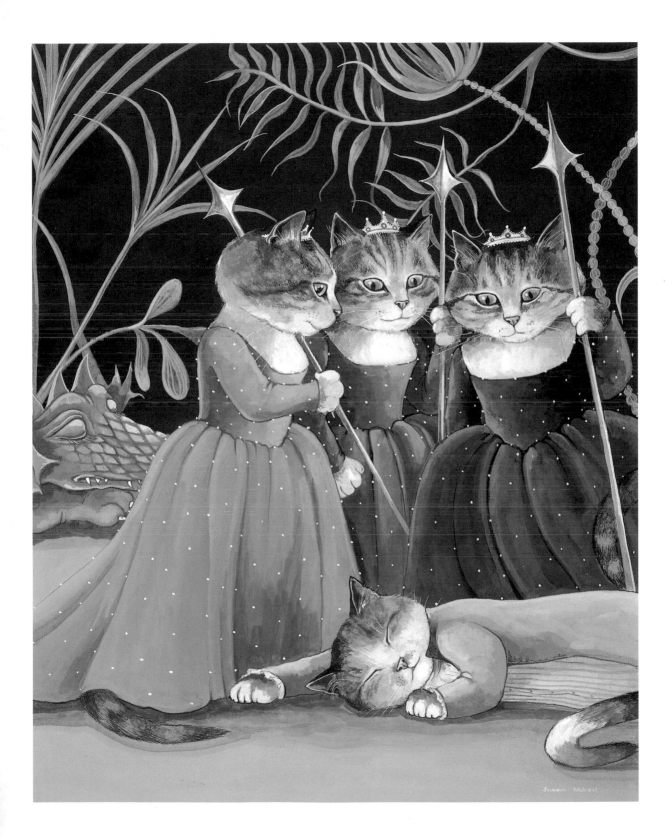

The Magic Flute

ACT II

*The vengeful Queen of the Night
gives her daughter a dagger,
and orders her to kill the High Priest, Sarastro.*

IT IS A CAT opera tradition that the Queen of the Night is played by a white Persian. Near the end of her career, Francesca Fischio dyed herself white to get the part. To make her coat appear fuller she was bathed and blown dry each evening. Her voice by then was harsh and limited, her figure bloated, yet she was still a commanding and vivid presence.

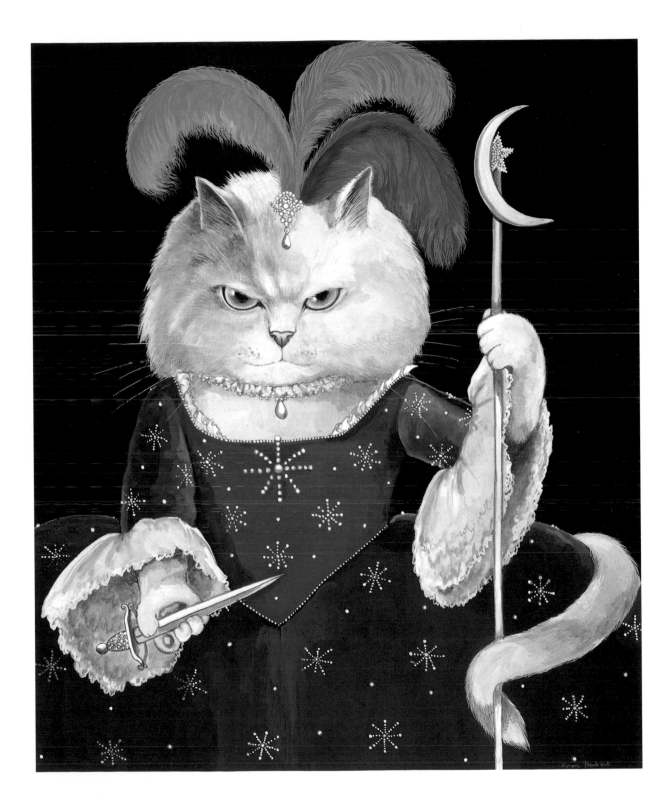

Die Fledermaus

ACT II

During his lavish party, Prince Orlovsky drinks a toast to the king of wines, champagne. The party is serving as a setting for Dr. Falke to take his long overdue revenge on his friend Gabriel von Eisenstein. To aid him in his plot, Falke has invited to the party Eisenstein's maid, Adele, disguised as an actress, and his wife Rosalinda, disguised as a Hungarian countess, and masked.

DURING ONE memorable performance. someone replaced the imitation champagne with real champagne. It takes very little alcohol to make a cat tipsy and a great deal is consumed in Act II. By Act III, Eisenstein was so drunk he was lurching about on all fours, unable to follow through on the plot, which required that he exchange clothes with Dr. Blind, his lawyer. Blind, played by an aging Tommaso Gatto, had the ingenious idea of pretending that he was Eisenstein dressed in Blind's clothes, but Eisenstein did not have the presence of mind to cooperate, and so both cats launched into Eisenstein's part of *"Ich stehe voll Zagen"* ("I am full of apprehension") while Rosalinda stared at them in amazement.

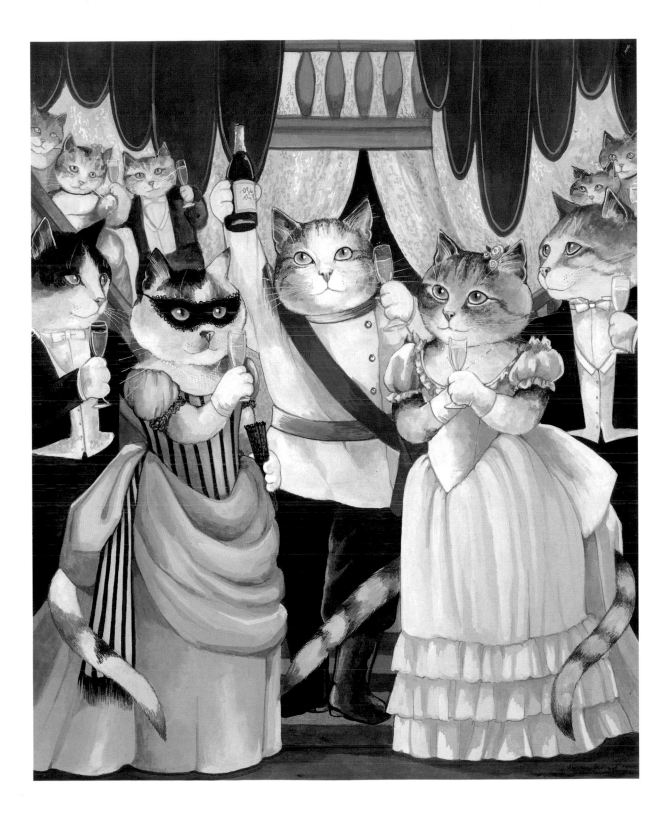

Madame Butterfly

ACT II

Although Pinkerton has been away for three years,
Cio-Cio San still believes that he will return.
Her maid, Suzuki, has her doubts.

THIS 1937 PRODUCTION of *Madame Butterfly* featured the American debut of the noted Siamese soprano Phlat Phurr. Impresarios are almost always unable to resist the urge to cast Siamese cat sopranos as Madame Butterfly, thinking that the spurious Asian authenticity will excite the audience. The Catropolitan's director, Gatto-Casazza , was no exception. But, as you can see, Suzuki, played here by the Swedish mezzo-soprano Inga Holdenstroken, was made up to look every bit as "authentic" as Phlat Phurr. In recent years, when the Abyssinian tenor , Ali Khet, has played Pinkerton at the Catropolitan, he has been made up to look impeccably Western, which goes to show that breeding counts for nothing when it comes to opera.

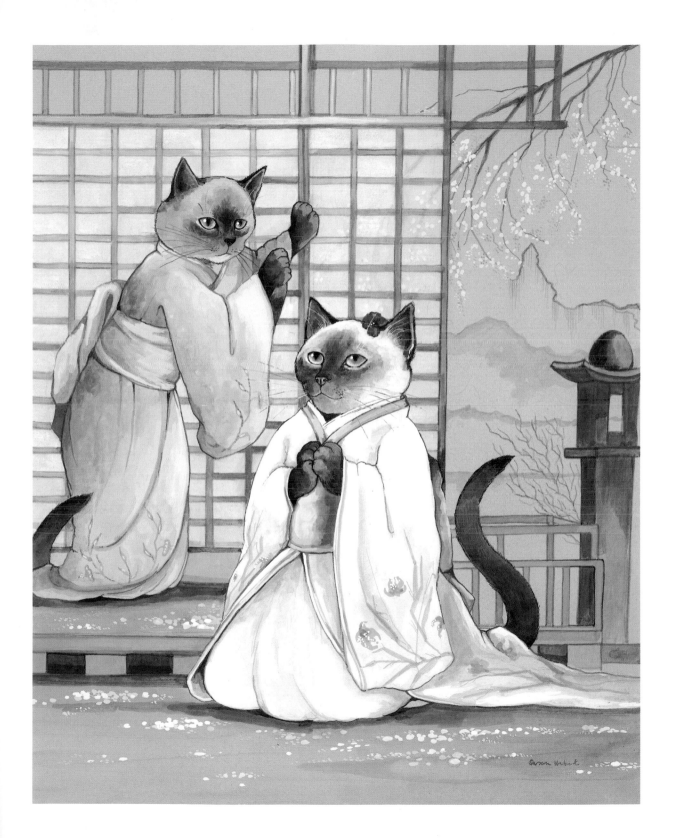

La Traviata

ACT I

Alfredo Germont is taken to a party at the house of Violetta Valery, a beautiful courtesan, whom Alfredo has loved from afar for more than a year.

EVERYONE IN THE COMPANY adored the late Fanny Clawson who made the role of Violetta her own over a 20 year career. I think it can only enhance our memory of her plucky personality if I reveal a secret that the company held in closest confidence. Notice, if you will, how her tail curves about her dress, insouciantly yet artificially. A nearly fatal backstage accident during a rehearsal for *Otello*, in which the scenery for Desdemona's bedroom came crashing down on her tail, required the amputation of Clawson's caudal appendage. Her career was at its peak, and to keep it from tailing off, the disfigurement was hushed up. Clawson always kept several artificial tails in her dressing room, each made up for a different part.

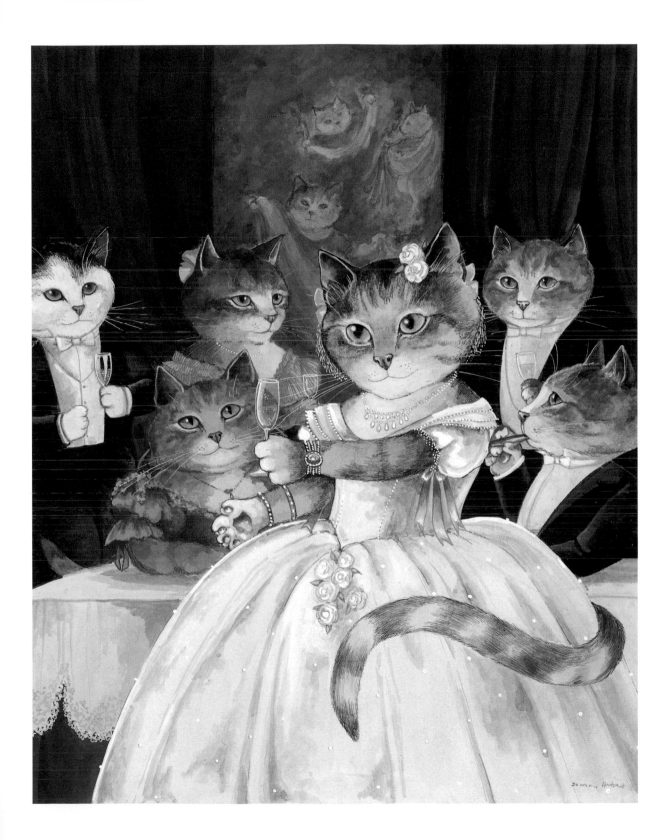

Violetta has left Alfredo at the behest of his father. Believing her to have returned to her lover,
Douphol, of her own free will, Alfredo catches up with her at Flora's gambling party,
and insults her by throwing his winnings in her face.

THE GREAT GREEK SOPRANO, Ailuria Katsos, took over the part of Violetta after Fanny Clawson left the scene. Her battles with Rex Manxman, the company manager, were legendary. She was the biggest star of her era, but her incessant demands for greater compensation exasperated Manxman. When she finally left the company for a better offer from La Scala Baffuto, she reversed the scene from *La Traviata*, throwing a pawful of money in Manxman's face at a gala reception.

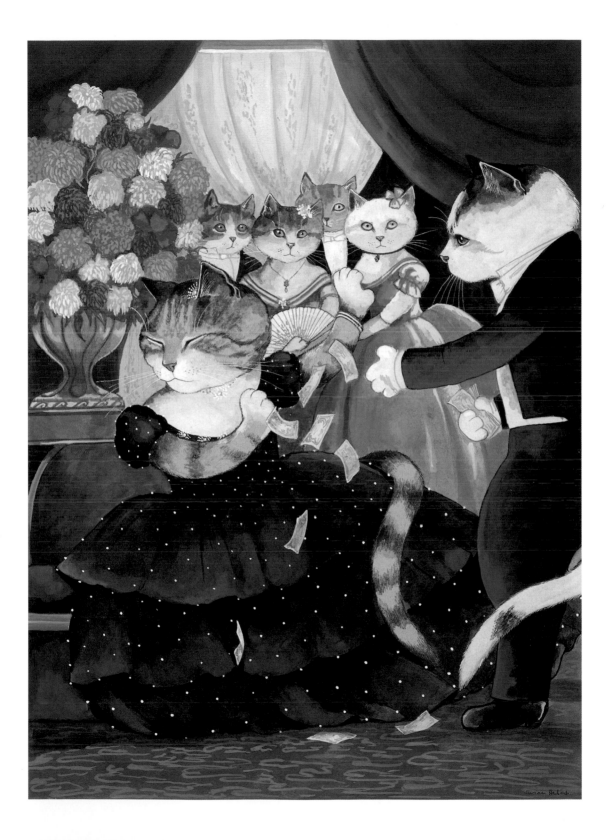

Così fan Tutte

ACT I

The cynical Don Alfonso persuades his young friends Ferrando and Guglielmo to test the fidelity of their fiancées Fiordiligi and Dorabella. Having pretended to go off to war, the two young men return disguised as Albanians and each attempts to win the affections of the other's sweetheart. At first, the two ladies will have nothing to do with them, so the "Albanians" pretend to take poison.

FIORDILIGI WAS SUNG in this production by Francesca Fischio in her Catropolitan debut. She would go on to become one of the greatest divas in the history of the company. She had an ego to match her talent, and a succession of company managers attempted to cope with her demands which grew more outrageous with each passing year. The final straw was the request for a security guard to be stationed at the door of her dressing room to protect her pet shrew while she was on-stage.

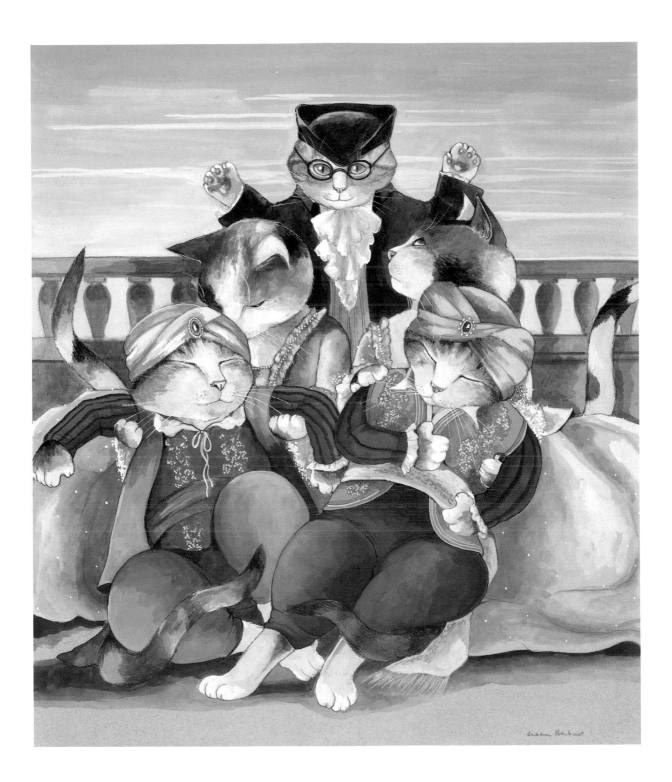

Pagliacci

ACT I

Canio, the leader of the strolling players,
has discovered that his wife Nedda is being unfaithful to him.
He sadly laments that he must don his make-up and
play the clown when his heart is breaking.

THESE DAYS, when marketing seems to take precedence over artistic integrity, the opportunity to steal the prodigiously gifted Leo Angorotti from La Scala Baffuto to sing Canio, was turned into an orgy of fundraising. Angorotti's leonine name and appearance were cynically exploited. All press releases referred to him as "The Big Cat" and at his debut the audience was given T-shirts which read "The Big Cat is where it's at."

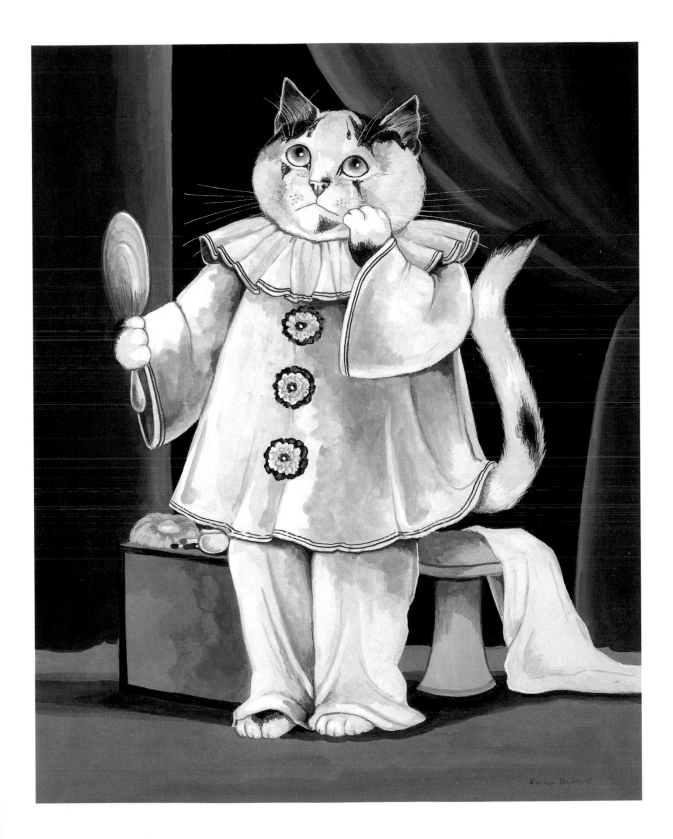

Das Rheingold

SCENE II

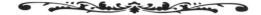

The giants Fasolt and Fafner have built the palace Valhalla for Wotan.
Wotan unwisely agreed to give them Freia, the goddess of youth, as their payment,
intending to find something else for them before payment was due.
This he has failed to do, in spite of Loge's help,
so the giants drag Freia away, refusing to return her unless
Wotan is able to get them Alberich's gold.

IT WAS GATTO-CASAZZA who had the idea of casting bulldogs as Fasolt and Fafner in this 1928 production. They were recruited from Moscow's Red Canine Opera Company and their arrival naturally raised tensions at the Catropolitan. Gatto-Casazza took responsibility for protecting the cast by keeping the dogs overfed and constantly drunk during their stay. Though the company received a huge amount of publicity, critics found the rather snorty intonation of the dogs quite unpleasant.

Das Rheingold

SCENE III

Having stolen the magic gold from the Rhinemaidens, Alberich makes himself Lord of the World, and exercises his power by forcing the other Nibelungs to obey him. Wotan and Loge, who have descended into Nibelheim with the intention of robbing Alberich of the gold, look on with interest and await their opportunity.

WHO SAYS CATS have no sense of humor! Pierre Puma, the black French dwarf, who sang Alberich more often than any other artiste, was fond of substituting a cat o' nine tails for the whip. And of course the director knew that Wotan's eye patch would remind everyone of the one-eyed cat in the well known rock and roll song *Shake, Rattle and Roll.*

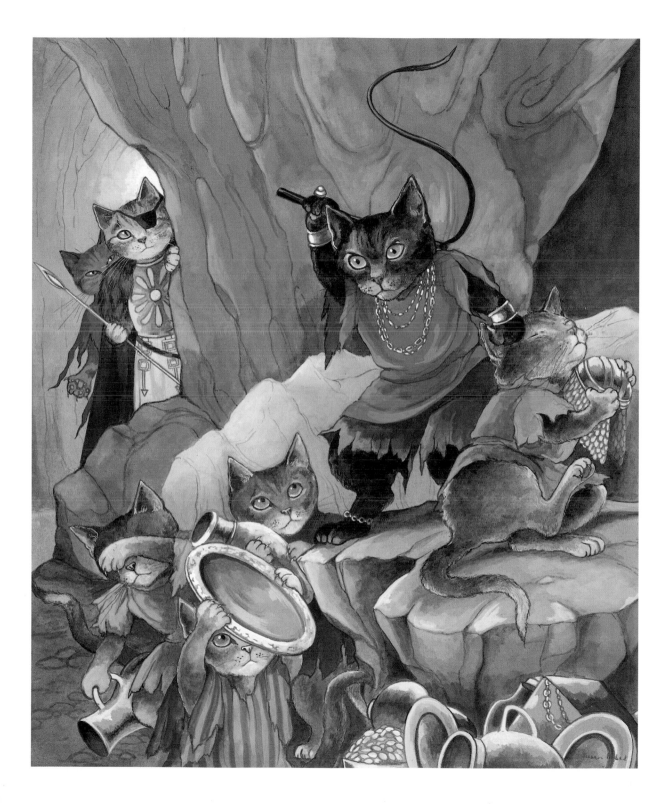

Siegfried

ACT I

The young Siegfried has forged his new sword, Nothung,
from the broken remains of his father Siegmund's weapon. Mime, the Nibelung,
kept the remains of the sword hidden, when he found Siegfried's mother Sieglinde dying in the forest,
having just given birth. Mime has raised Siegfried, in the hope that his mighty strength
will be enough to vanquish Fafner, who has transformed himself into a dragon
and is the current holder of the Ring.

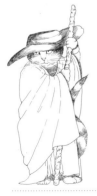

THE ORIGINAL of this illustration hangs in the Leo Angorotti Memorial Cafeteria. It seemed an appropriate gesture, since Siegfried was Leo's last role. Everyone knows the story by now, how Angorotti decided to see whether the bulldog who had been cast as Fafner in the 1975 production would sound better if he were not given such heavy doses of alcohol to keep him complacent. Poor Leo, in his self-confidence he neglected the First Law of Cats: Never, ever, be curious.

Boris Godunov

PROLOGUE

*Russia is suffering, and the people long for a new tsar who will bring peace and justice.
Boris Godunov has been crowned with full ceremony. However, he has a bad
conscience, since he was responsible for the death of Dmitry,
the son of the previous tsar Ivan the Terrible.*

THIS PRODUCTION saw the Catropolitan debut of Alexander Katnips, the great Russian bass. Unlike human opera, where good tenors are in short supply, in cat opera good baritones and, especially, basses are a rarity. Though almost every cat can produce a deep-throated purr, when it comes time to project a resonant caterwaul, the voice rises. (In the 18th and 19th centuries of course, some cats resorted to regrettable and dangerous transplant operations, now thankfully illegal; though it did produce a steady supply of deep-voiced singers, referred to as bassati.) Katnips' career with the company lasted for nearly a decade, until, as he aged, his voice lost its bottom.

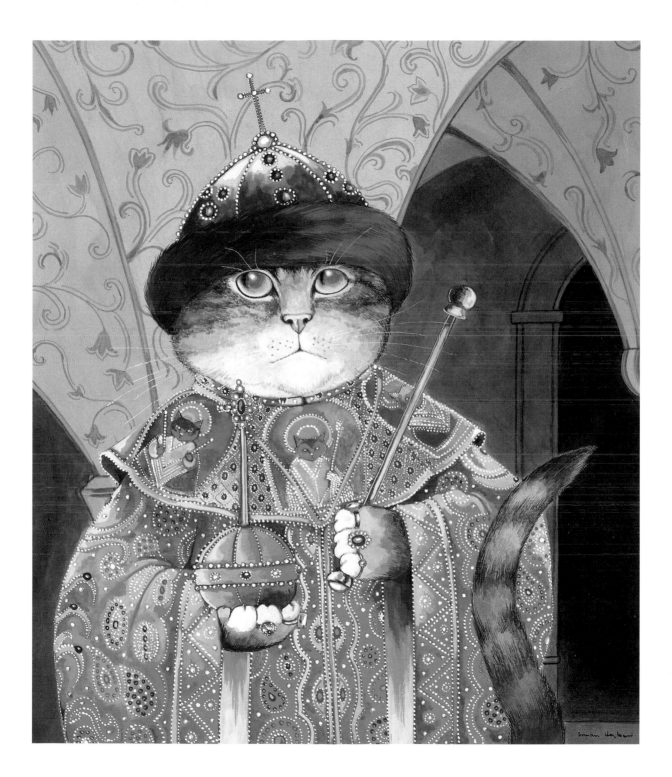

Eugene Onegin

ACT II

*At a party, Eugene Onegin deliberately
provokes his friend Lensky by flirting outrageously with Lensky's beloved, Olga.
Lensky challenges Onegin to a duel, and Onegin kills him.*

AS YOU CAN SEE, when cats stand back to back and upright, their tails tend to wind about their legs. One evening, when Onegin, played by the great Russian tenor Nikolai Goddakatskan, whirled to fire his pistol, he discovered that Lensky had tripped over his tail before taking a single step. It seemed rather ungentlemanly to shoot Lensky as he lay on the ground, but Goddakatscan had no choice.

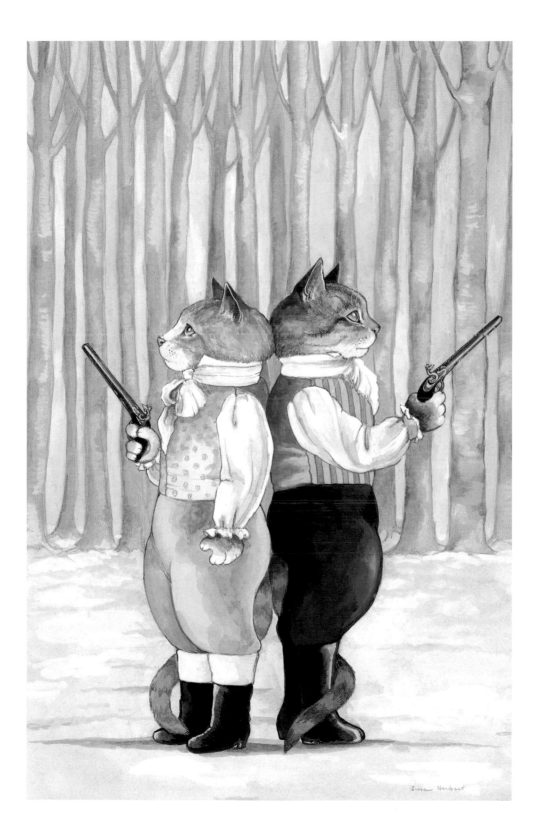

Tosca

ACT II

To save the life of her beloved Cavaradossi,
Tosca has agreed to spend the night with Scarpia, the chief of police.
Once the order of release is signed, Tosca stabs the evil Scarpia to death.

HERE IS Catherine Kittle, who didn't limit her knifework to the stage. Although the story has been hushed up, she did in fact stab Leo Angorotti in her dressing room. The cause of their dispute has never been revealed, but she was heard to scream, "The little cat doesn't know where it's at!"

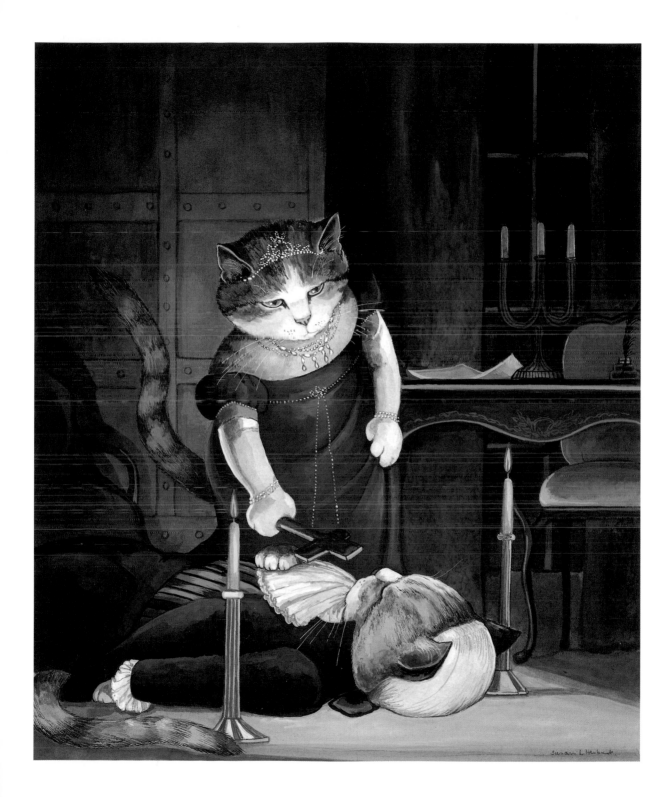

Die Walküre

ACT III

After the death of Siegmund and Hunding, Brünnhilde rescues Sieglinde, against her father's orders. She appeals to the other Valkyries to shield her from Wotan's rage.

SOME 90 YEARS after her Catropolitan debut, Inga Holdenstroken remains the greatest Brünnhilde of her own, or almost any other, era. She was famed for her appetite (half a pound of steak tartare before every performance) and over the course of her long career she outgrew four Brünnhilde breastplates. With her strength, Inga Holdenstroken was able to haul small Sieglindes about the stage. Occasionally she would sling one over her shoulder for dramatic effect, though an unfortunate spearing incident cured her of the practice.

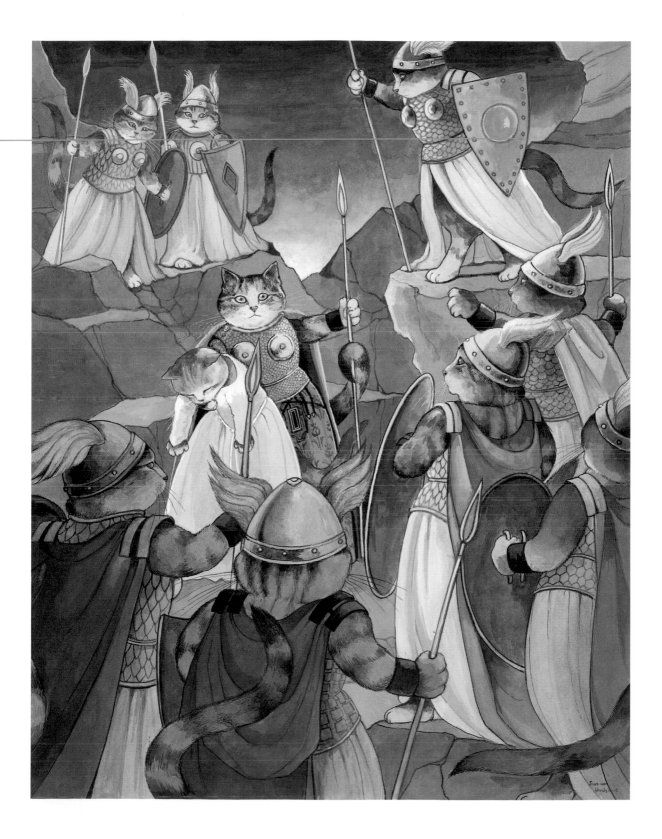

Die Walküre

ACT III

Despite Brünnhilde's pleading, Wotan is determined to punish her by depriving her of her supernatural status and putting her to sleep, to be defenceless against the first man who wakes her. However, to ensure that only a hero will be able to do this, he agrees to surround her with a ring of fire. Then he bids her a sad farewell.

BY THE MIDDLE period of Holdenstroken's career, there was not a male cat in the company who was even close to her size. Leo Angorotti refused to appear next to her. After a long search for a new Wotan, Alphonso Oceloto was found in a light opera company in San Francisco. He was lazy and stupid, but considerably larger than Holdenstroken. Though his voice was barely adequate, the two of them dominated the stage.

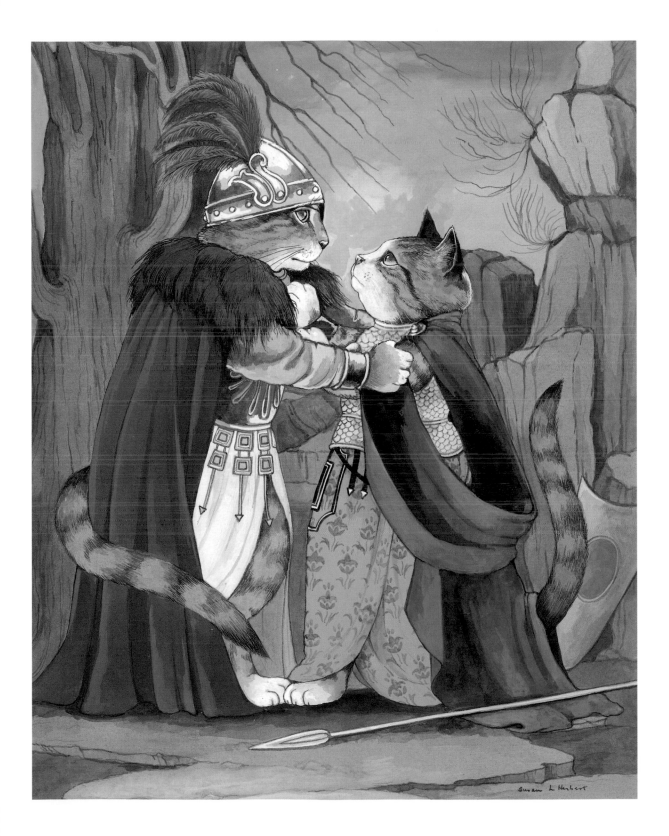

Tristan und Isolde

ACT I

Tristan is taking the Princess Isolde back to Cornwall, as a bride for King Mark.
They are deeply in love, though neither has admitted this to the other.
Isolde plans a suicide pact with poisoned wine, but before they drink,
Isolde's maid Brangane substitutes a love potion for the poison.
By the time they arrive in Cornwall, Tristan and Isolde are
irrevocably besotted.

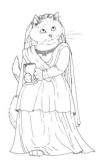

ISOLDE WAS ANOTHER important role for Inga Holdenstroken. Unfortunately, Tristan was outside Alphonso Oceloto's range, and so she was forced to sing at the foreheads of a number of Tristans. The costume designers tried to help, by dressing her in floor-length gowns so she could crouch surreptitiously. It is, of course, quite difficult for cats to crouch when standing on their hind legs, and one wonders if the look on her face is really love.

Die Micetersinger von Nürnberg
ACT III

Walther von Stolzing competes in the singing contest
before the assembled mastersingers.
He is in love with the beautiful Eva who is the prize.
To ensure Walther's victory over
his rival Beckmesser, the kindly cobbler-poet Hans
Sachs has helped him to create
his winning song.

LONG AFTER Alphonso Oceloto's voice had descended from barely acceptable to a pathetic croak, he was still cast in major parts opposite Inga Holdenstroken, at her insistence, because he was the only tenor in the company who was larger than she. Nothing more grotesquely illuminated the drawbacks of this approach than the Catropolitan's production of *Micetersinger*, in which Oceloto, as Walther, must win Eva by his singing. Judging by the audience's applause, Beckmesser won, paws down, every evening.

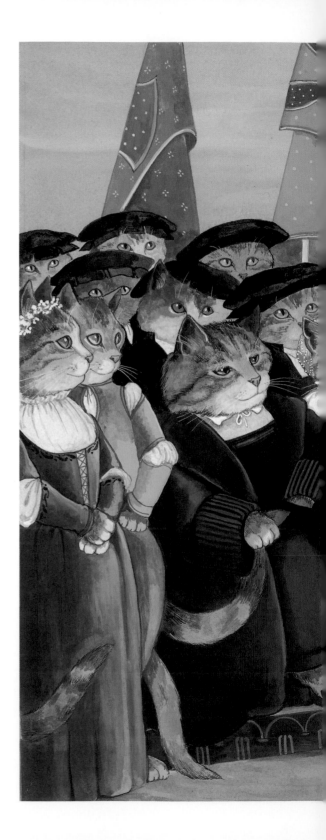

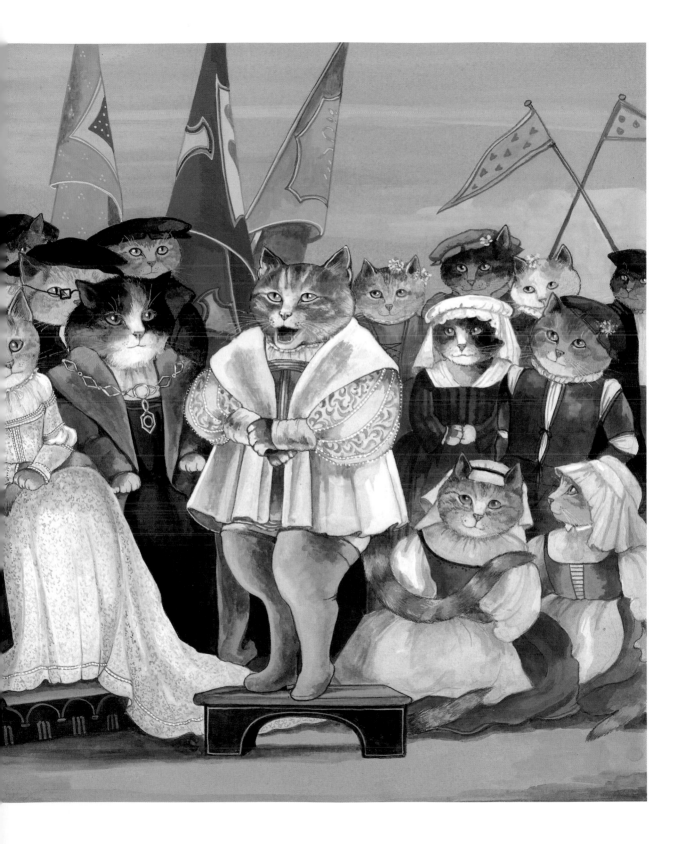

Don Giovanni

ACT II

The libertine, Don Giovanni, having killed Donna Anna's father,
mocks the dead man's statue in the churchyard and makes the mistake of inviting it to dinner.
He is considerably alarmed when the statue arrives to keep the appointment.

THE COMPANY HAS always regarded Mozart as a particularly "feline" composer and at one time or another has presented virtually every one of his operas. Alexander Katnips, who sang the title role during the 1948 season (late in his career, when his voice became lighter), was himself a notorious libertine. During the season of this production, the wardrobe mistress was forced to make weekly adjustments to the costumes of Zerlina, Donna Elvira, and Donna Anna to disguise their incipient litters.

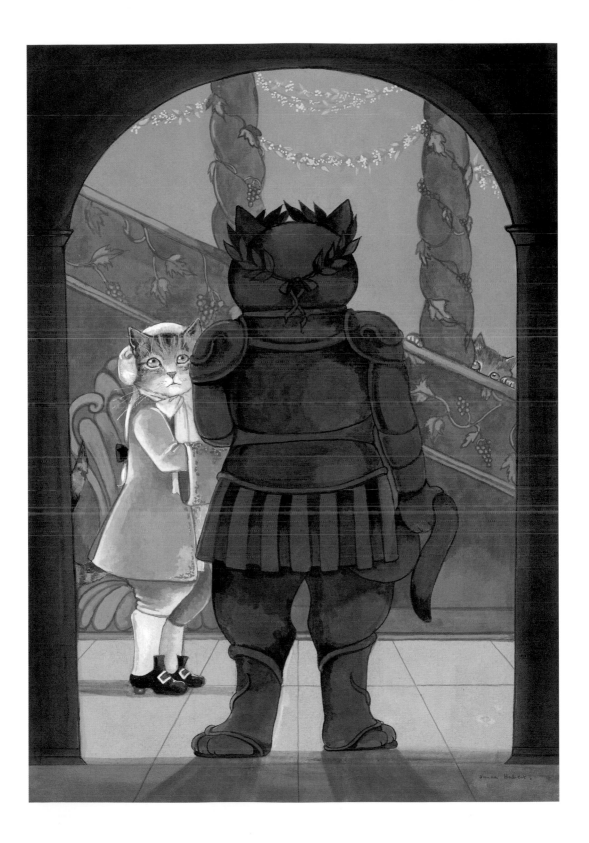

The Marriage of Figaro
ACT IV

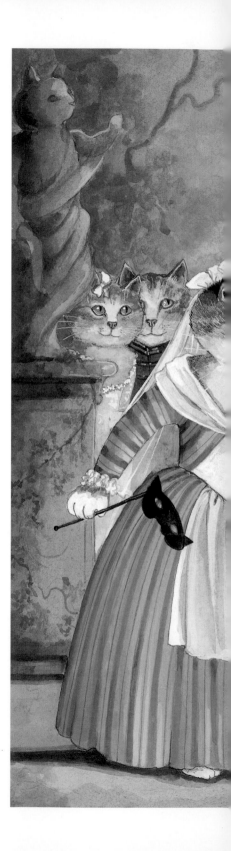

*Count Almaviva begs forgiveness of his Countess.
He has been foiled in his pursuit of Susanna
(Figaro's betrothed) by the Countess and Susanna
exchanging dresses and wearing masks.*

THE COMPANY has always enjoyed
operas with elements of disguise and
deception. Ailuria Katsos, who played
the Countess, was in fact a deadly enemy
of Lola Zampa, the Argentinian soprano
known as "Zampa di Pampa" who played
Susanna. One night Katsos actually refused
to exchange costumes with Zampa, forcing
Zampa to appear "naked."

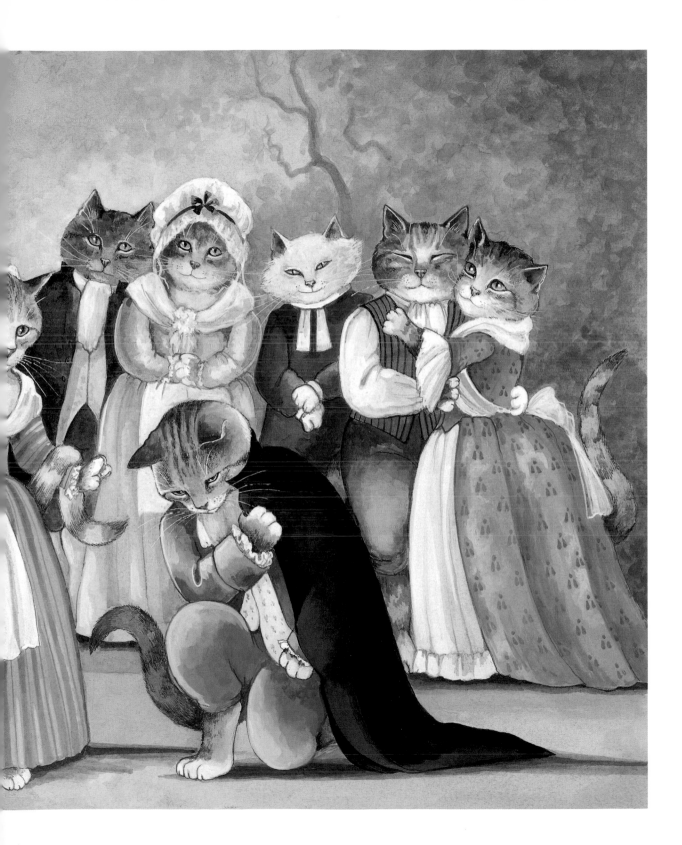

Fidelio

ACT I

Leonora and Jaquino open the doors of the State Prison, and all the prisoners emerge into the light. Leonora is disguised as Fidelio, and is trying to find out the whereabouts of her husband Florestan, who has been wrongfully imprisoned by the evil Pizarro.

IT IS SAD that the company has never really mounted a successful production of *Fidelio*, at least successful with the general public. Perhaps Beethoven's soaring idealism, his heartfelt testament to freedom and heroism, just doesn't look good on cats.

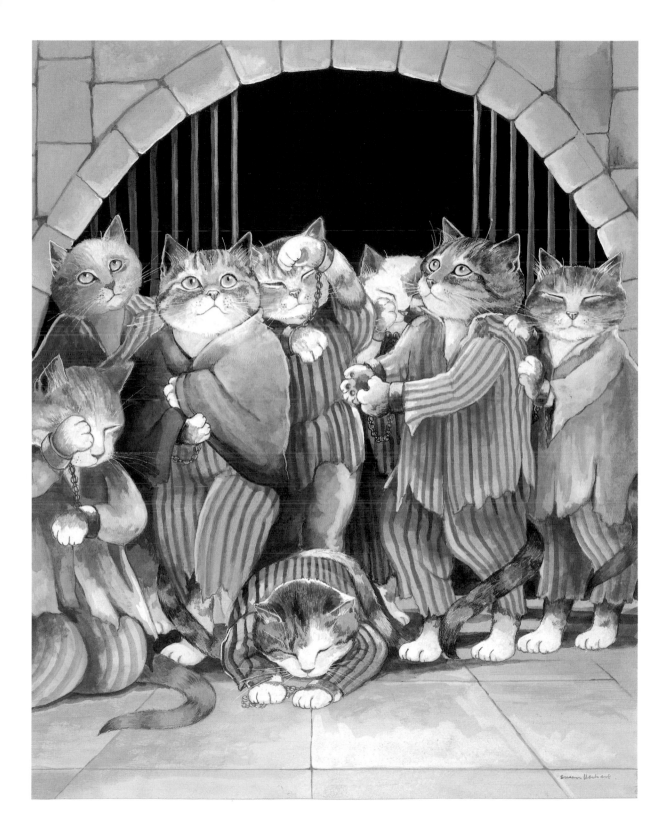

Cavalleria Rusticana

The peasant girl Santuzza has been jilted by her lover Turridu, who has returned to his former love, Lola, although she is now married to Alfio. Santuzza has been excommunicated, and laments her lot while everyone else files into the church on Easter Sunday.

AS IS TRADITIONAL, the Catropolitan performs this one act opera together with *Pagliacci*, and the double bill is a great favorite with audiences. When the Catropolitan planned the grand gala for the opening of the Purina Center for the Feline Arts, it was assumed that the performance would be of a very grand opera; Leo Angorotti's suggestion that they perform "Cav and Pag" was met with derision. Angorotti persisted, pointing out with unusual generosity, that the bill would provide more members of the company with a chance to shine. Since a gala could not be imagined without Angorotti's participation, the company acceded, only to discover that most of the shining would be done by the Big Cat, who intended to play the lead in both operas. For Angorotti it was, as they say, an individual triumph.

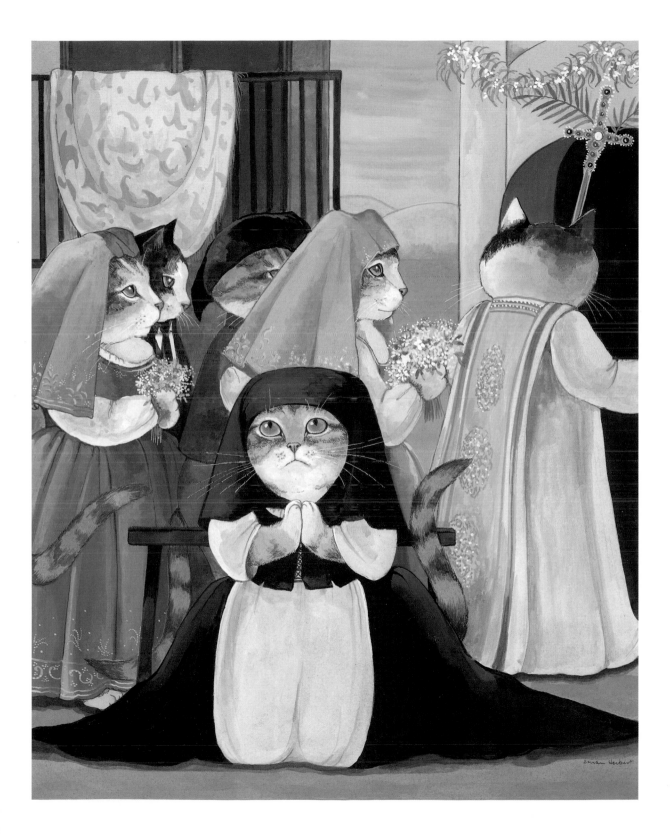

Lucia di Lammermoor

ACT III

*Enrico forces his sister Lucia into marriage with Arturo,
knowing that she is really in love with Edgardo.
On her wedding night, Lucia stabs her new husband
to death, and then goes completely off her head.*

MANY PEOPLE thought it was typecasting when the Catropolitan Opera gave the title role to Catherine Kittle. Even in a company inured to the antics of Francesca Fischio and Ailuria Katsos, Kittle stood out. Whenever she appeared, the entire company was on edge since any slight could evoke her vindictive wrath. One memorable evening she canceled her appearance shortly before the curtain after screaming at Rex Manxman that no artist could survive under the conditions imposed by the Catropolitan Opera. It turned out that her dressing room had been furnished with domestic kitty litter instead of the imported variety that she preferred.

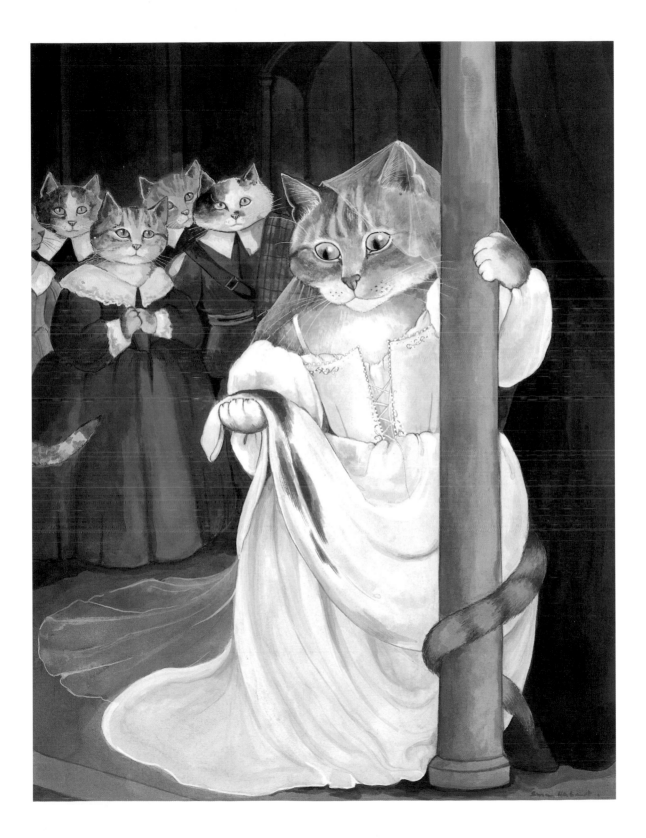

Faust

ACT III

Faust, having sold his soul to Mephistopheles, has regained his youth. He woos the chaste young Marguerite in her garden, while Mephistopheles looks on.

AS MUST HAPPEN to all cats, the Big Cat became an Old Cat. Had Mephistopheles appeared before Leo Angorotti, I am sure he would have sold his soul to fend off the ravages of age. Instead he consumed quack remedies for impotence and gray hair, such as the pituitary glands of Tibetan mice. All to no avail, and the sadness that enveloped the Big Cat as his gifts declined, added a special note of poignant desperation to his performance as Faust.

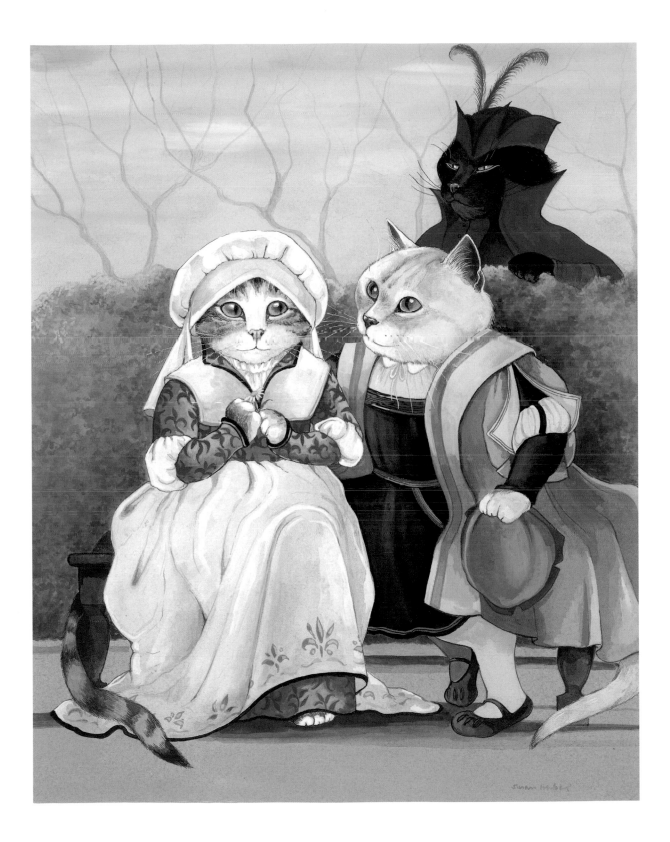

Rigoletto

ACT II

Gilda, the daughter of the jester Rigoletto, has been abducted by the Duke of Mantua's courtiers. The Duke, who has been wooing Gilda on the quiet, disguised as a student, no sooner finds her in his own palace than he seduces her. Her father comforts her in her shame and despair, and swears vengeance on the Duke.

THIS SUMPTUOUS, lavish *Rigoletto* is, in my estimation, the greatest of Rex Manxman's productions. Its enduring magnificence is an implicit repudiation of the "trendy" predilection for staging classic operas in a modern dress. I am thinking, of course, of the recent meretricious version of *Rigoletto* in which the Duke of Mantua is the leader of a pack of feral cats in the Hamptons. Directed by a certain longhaired *chaton terrible*, its memory is recorded in the annals of banality.

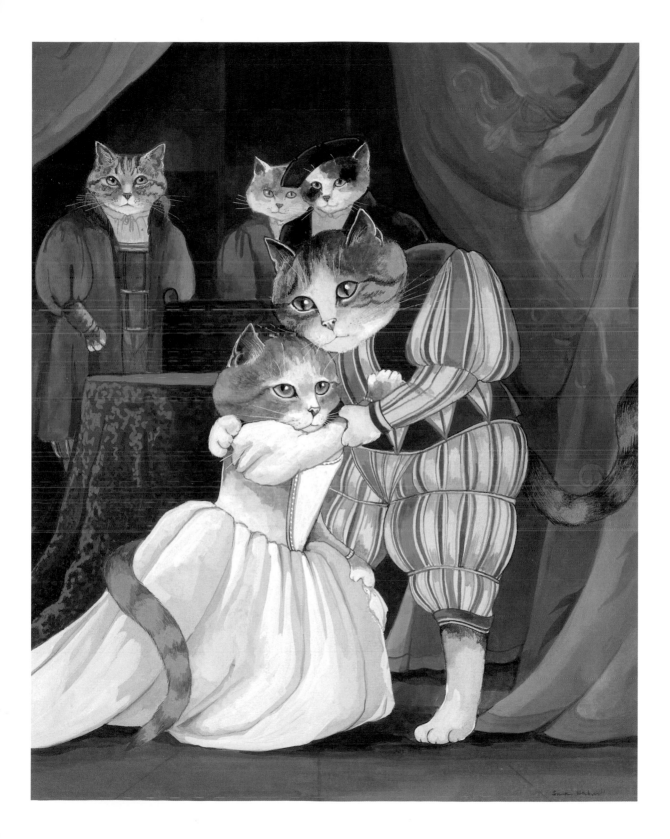

The Barber of Seville

ACT I

*The barber, Figaro, recounts the many reasons why he is indispensable to everyone in Seville.
He is about to assist the young Count Almaviva in his pursuit of Rosina, who is kept confined
to the house by her guardian, Dr. Bartolo.*

THIS MOST POPULAR of comic operas was chosen for the first performance of the Catropolitan's first European tour. The tour began, daringly, in Milan, home to the oldest cat opera company, La Scala Baffuto. The Italian company, convinced there was only room in the world for one cat opera company, persuaded the theater managers of Milan to refuse to rent their theaters to the Catropolitan. A theater was finally located in an unsavory part of Milan, next door to a cathouse. When the curtain rose, the audience, packed with members of the Italian company, greeted the Catropolitan with a chorus of boos and catcalls and lobbed hairballs at members of the cast. The singers persisted gamely but relations between the two companies have never been repaired.

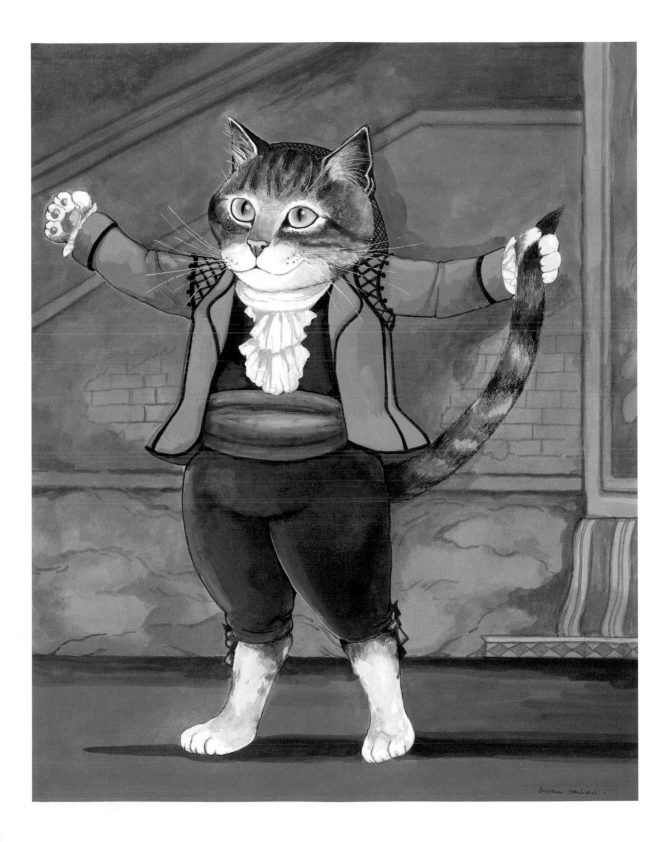

Carmen

ACT IV

*The fickle Carmen, having transferred her affections from
the disgraced corporal, Don Jose, to the toreador, Escamillo,
rejects the pleas of her former lover outside the bull-ring.
In a fit of jealous rage and despair, Don Jose kills her.*

DEVOTEES OF THE company groan at
the number of times that *Carmen* is scheduled
each year, but a significant part of the
Catropolitan's audience is not so much
interested in opera as in the novelty of cats
performing opera, a fact that may come as a
surprise to some readers. It is this "casual"
audience that adores *Carmen*, perhaps because
the passionate tale of fickleness and betrayal
seems particularly catlike.

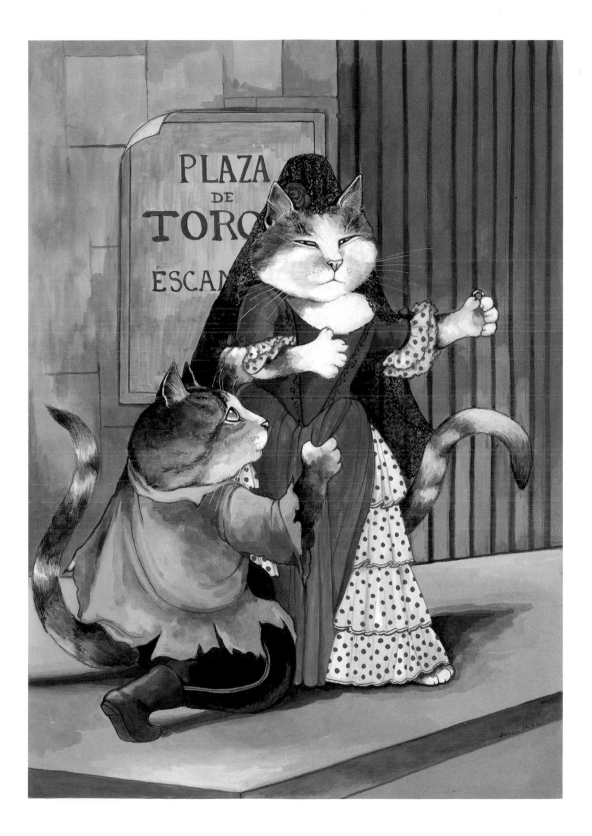

La Bohème

ACT II

The four friends (poet, composer, painter, philosopher) and their neighbor, Mimi, have an evening out at the Café Momus. Their enjoyment is interrupted by the arrival of Musetta and her elderly lover, Alcindoro. Musetta is the former love of the painter Marcello, and while Alcindoro studies the menu, Musetta seeks to draw Marcello back into her net

ACT IV

Some time after parting from her lover, Rodolfo, the seamstress Mimi arrives at his attic home, in the last stages of consumption. Everyone rallies round to help; Musetta fetches her muff for the ailing Mimi, and the philosopher Colline pawns his old overcoat to buy medicine for her. But it is too late, and Mimi dies soon after her arrival.

AS WRONG AS *Fidelio* is for cats, *La Bohème* is right. No opera seems more suited to a Cat production than *La Bohème*, with its intimate story, its characters who live by their wits on the margins of the city, characters whose romantic involvements are dramatic yet transitory. *La Bohème* has had at least five separate productions over the years, yet in my mind's eye they seem to merge into one wonderful tapestry of the Catropolitan Opera: Leo Angorotti's heartfelt Rodolfo, the only role he consistently played without preening self-involvement; Catherine Kittle and Francesca Fischio, as Mimi and Musetta, looking for love in all the wrong places; Alexander Katnips' vivid Marcello. It is in such productions that the Catropolitan, like all opera, takes leave of its unlikely circumstances and rises to a level of cathartic art.

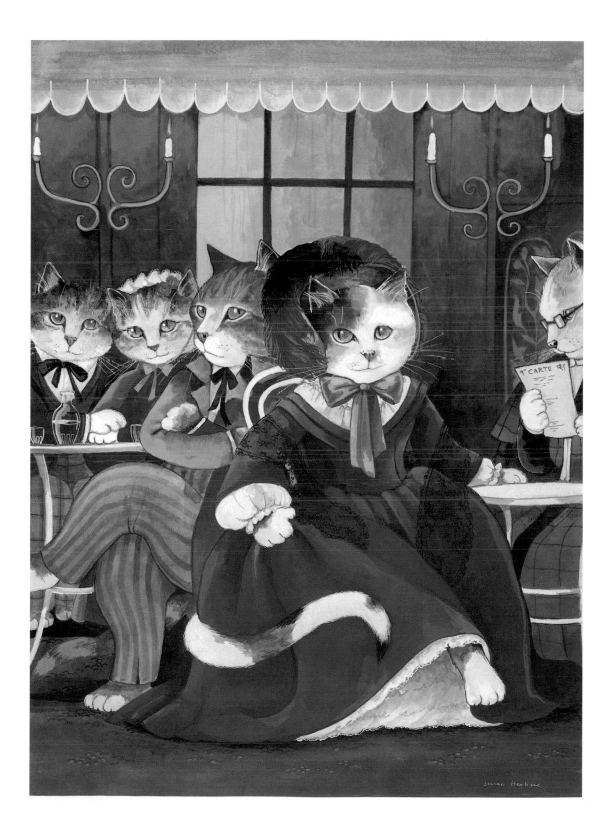

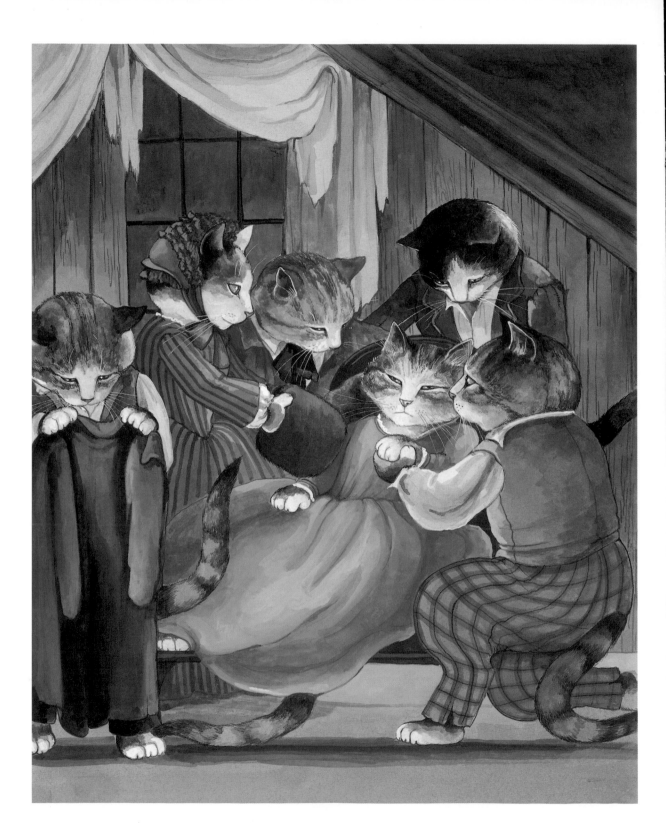